Chris Drange Relics

Chris Drange

Relics

MATERIALVERLAG–HFBK

HATJE
CANTZ

Frauen: Sie gehören zu den meist-abonnierten Personen auf Instagram. Berühmte Influenzerinnen wie Selena Gomez, Gigi Hadid oder Kendall Jenner präsentieren dort ihre Selfies – und werden dafür millionenfach verehrt. RELICS behandelt dieses Thema und stellt den Kommentaren der Follower ausgewählte Selbstporträts als Refotografien gegen-über. Dabei verweist der Titel auf zwei Phänomene: Erstens auf eine neue Form der Verehrung, in der Selfies zu digitalen Objekten der Anbetung und Smartphones zu „Schrein-Devices" werden. Und zweitens auf ein Frauenbild – im Spannungsfeld zwischen antiquierter Männervorstellung und moderner weiblicher Selbstbestimmung.

Women: they belong to the most followed people on Instagram. Famous influencers like Selena Gomez, Gigi Hadid, or Kendall Jenner present their selfies on this platform—and are worshipped for them by the millions. RELICS deals with this subject by juxtaposing appropriated photos of their self-portraits with the corresponding commentaries of their followers. The title points to two phenomena: one is a new type of worship, in which the selfie becomes a digital object of devotion and smartphones become "shrine devices". The other is the image of women—caught between an antiquated male projection and modern female self-determination.

#
mileycyrus

##
selenagomez

###
arianagrande

#
gigihadid

##
kendalljenner

###
kyliejenner

#
kimkardashian

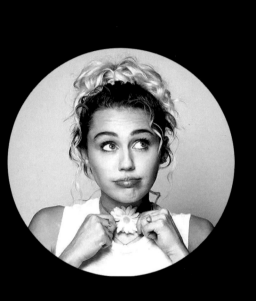

#
mileycyrus

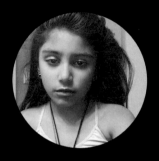

jamster_vader 🖤✨🖤✨🖤🖤✨🖤✨🖤✨🖤
✨🖤✨🖤✨🖤

#

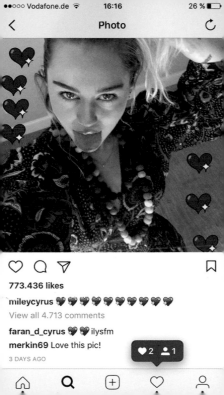

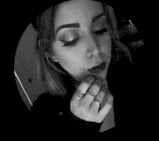

lindsaaaymaria Can I loveee you better? 🤍 dont worry, I´ll kiss it kiss it better baby 😘 😘

\#

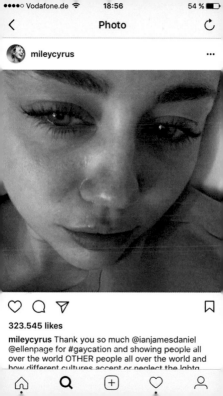

♡ ⃝ ⊿ 🔖

323.545 likes

mileycyrus Thank you so much @ianjamesdaniel @ellenpage for #gaycation and showing people all over the world OTHER people all over the world and how different cultures accept or neglect the lgbtq

luizaoliveira0207 Do you think I changed? I do not think I am matured, and learned from the pain that people we love, if you go, I let them go, because if they love us the same intensity, they always remember us, even if it is a faint smile or in memory of a time

\#

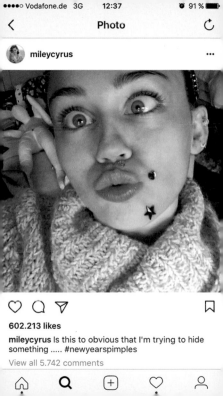

●●●●○ Vodafone.de 3G 12:37 ⏱ 91 %

< **Photo** ↻

mileycyrus •••

♡ ◯ ◁ ☐

602.213 likes

mileycyrus Is this to obvious that I'm trying to hide something #newyearspimples

View all 5.742 comments

⌂ Q ⊕ ♡ 👤

cutiepie_1010 Thats her mouth

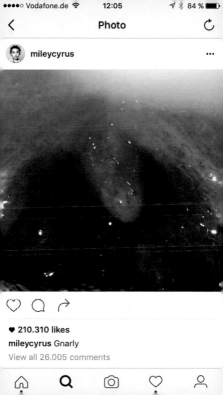

♥ 210.310 likes
mileycyrus Gnarly
View all 26.005 comments

chelsaquinn @mileycyrus What is
the cream/skin product that you use?
YOu have wonderful skin, and i feel
like I would benefit from the product/
products you use. Please help me, I am
staring my career of acting, and this
could help. <3

#

mileycyrus •••

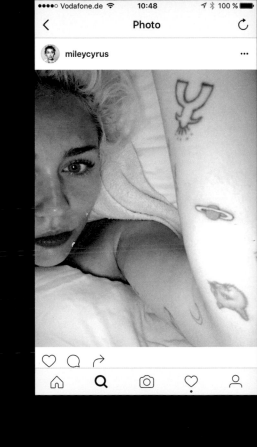

♡ ◯ ↱

⌂ 🔍 ◎ ♡ ◯

cenicientacinderella6688 🖤 🖤

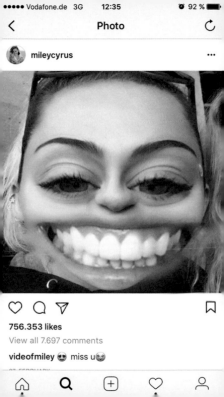

mileycyrus •••

♡ ◯ ◁ 🔖

756.353 likes

View all 7.697 comments

videofmiley 😍 miss u 😭

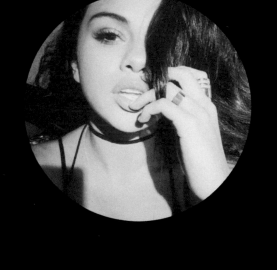

selenagomez

brianabdlt @selenagomez You are the most 😍 Gorgeous 😍 human being with and without makeup 😍

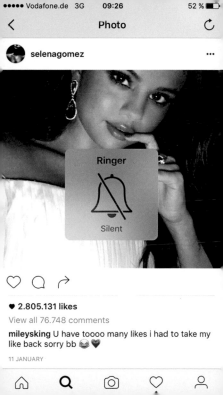

selenagomez •••

Ringer

🔕

Silent

♡ 💬 ↱

♥ **2.805.131 likes**
View all 76.748 comments

mileysking U have toooo many likes i had to take my like back sorry bb 😂 🖤

11 JANUARY

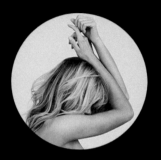

rosaliess Please see meeee. Please see meeeee

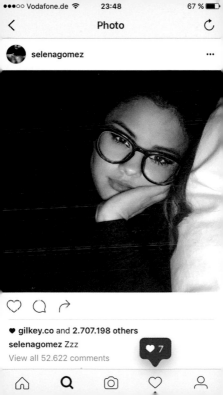

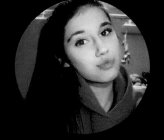

nicole_wonsowicz You´re pretty no matter what 😘

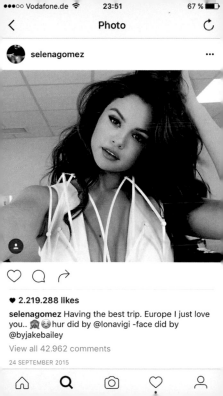

selenagomez ···

♡ ○ ↱

♥ **2.219.288 likes**

selenagomez Having the best trip. Europe I just love you.. 🙆‍♀️😊hur did by @lonavigi -face did by @byjakebailey

View all 42.962 comments

24 SEPTEMBER 2015

⌂ 🔍 ◎ ♡ 👤

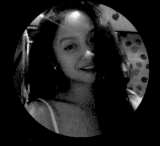

mayailisya @aliahcheaz we kinda look alike

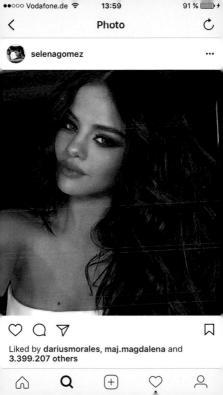

selenagomez ...

Liked by **dariusmorales**, **maj.magdalena** and **3.399.207 others**

eulanecoutinho Hi?

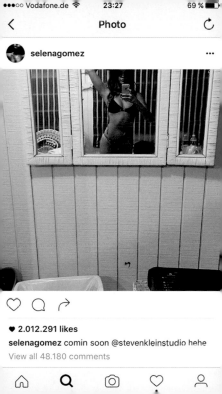

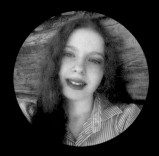

frida__avetisyan__ I love you selena you are my Goddess, you are my universe, you will be unique my heart and no one will replace 🐾🐾🐾🖤🖤🖤🖤🖤🖤 you are my Queen

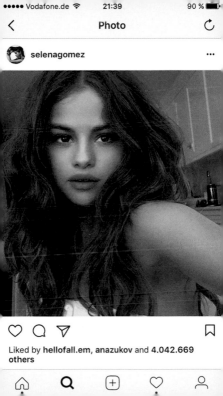

♡ ☐ ◁ 🔖

Liked by **hellofall.em**, **anazukov** and **4.042.669 others**

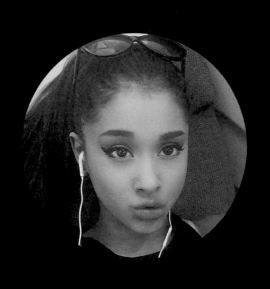

###
arianagrande

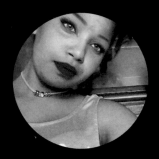

pieta230 I wish to be you

###

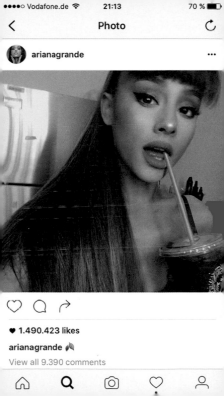

arianagrande ···

♡ ◯ ↱

♥ **1.490.423 likes**
arianagrande 💨
View all 9.390 comments

🏠 🔍 📷 ♡ 👤

__jena__kim Love u

###

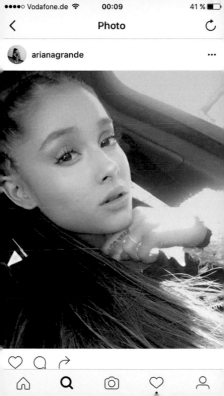

blxssd79 IM YOUR BIGGEST FAN ARIANA IM CRYING CAUSE I LOVE U SO MUCH I CANT STOP CRYING U ARE BEAUTYFUL AND CUTE OMGG I CANT STOP CRYING PLZ REPLY I LOVEEEEEEE U ARIANA I LOVE U 😭😭😭😭 😘😘😘😘

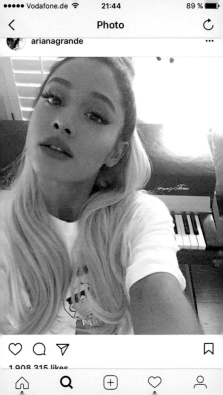

♡ ◯ ✈ 🔖

1.908.315 likes

⌂ 🔍 ⊕ ♡ 👤

bosoeteman hey ariana, all of these 👆 people who say, i love you dont really know you. but i think that you are a amazing and wonderful girl/woman, i dont love you because i dont really know you but if someone ask me: what do you think of ariana? i said: i think she is a beautyfull sweet and lovely girl and i am sure that you are!! so dont doubt about your sing or look because you are strong and everybody likes you, some people are just jalous, but ignore them. i really really really hope that you read this and maybe like on of my pics 😭 🖤 but im sure that you are the most beautifull girl in the world keep om girl! xxxxxxxx

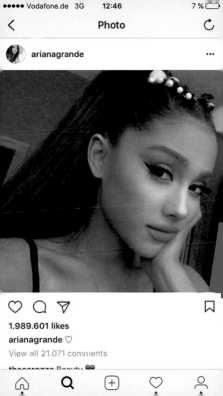

wildanimallover.l.o.w.a4 💕 😚

###

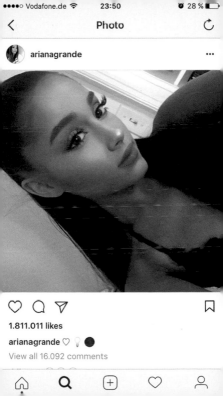

♡ ◯ ◿ 🔖

1.811.011 likes

arianagrande ♡ 💡 ⚫

View all 16.092 comments

⌂ 🔍 ⊕ ♡ 👤

sophia_owll I was born with a some blonde at the bottom of my hair

###

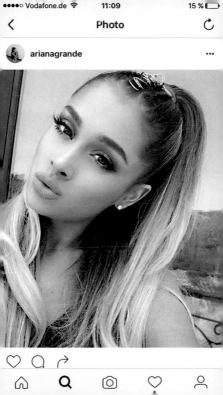

♡ ◯ ↱

⌂ 🔍 ◎ ♡ 👤

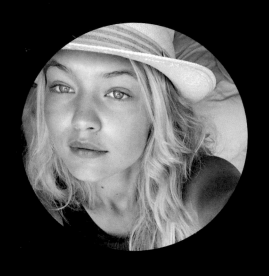

#
gigihadid

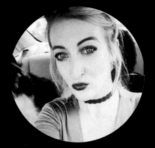

tmpatt0890 Omg what it would be be like to wake up like that!! Beautiful is an understatement 😍 🤤

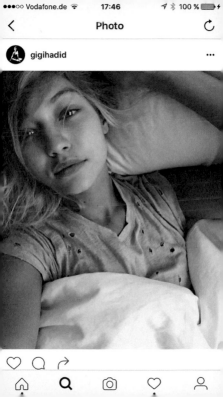

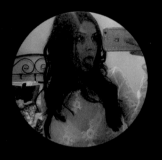

jayda.amico @emilysuppa follow her so
u can cry 😭 😍

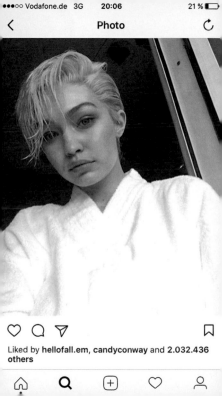

♡ ◯ ◁ ⊡

Liked by **hellofall.em**, **candyconway** and **2.032.436 others**

⌂ 🔍 ⊕ ♡ 👤

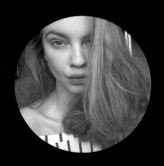

lottejansma you are beautifull

gigihadid ···

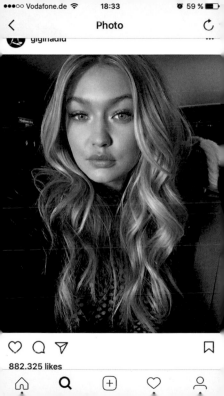

♡ ◯ ◁ 🔖

882.325 likes

⌂ 🔍 ⊕ ♡ ○

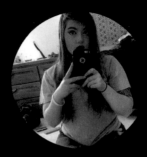

ayedeecee__ Wooooow so flawless!!!
Ugh wish I looked like you .. 😔

#

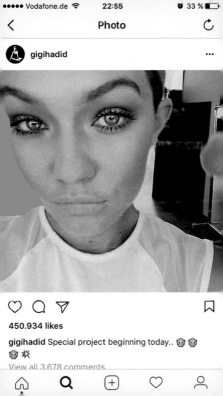

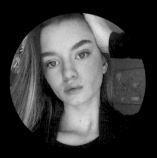

victoriasapeta you are my role model
🖤 🖤 🎀

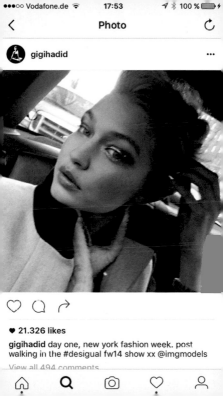

gigihadid •••

♡ ◯ ↗

♥ **21.326 likes**

gigihadid day one, new york fashion week. post walking in the #desigual fw14 show xx @imgmodels

View all 494 comments

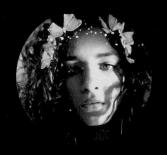

sofie_wallace CAN I BE YOU!

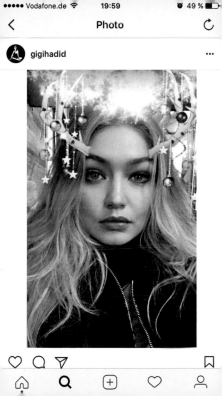

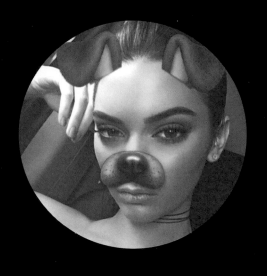

##
kendalljenner

l.o.r.x. OMG, you´re so beautiful baby

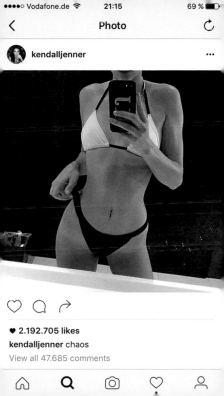

izzaghassani You´re so pretty Kendall it´s not fair

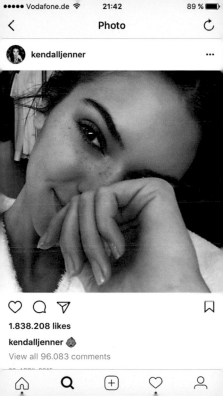

_angelsquad Beautiful ✨

##

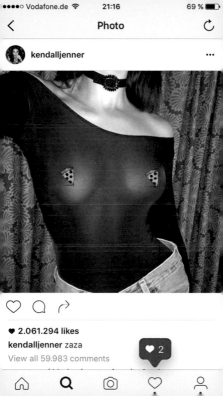

kendalljenner

•••

♡ 2.061.294 likes

kendalljenner zaza

❤ 2

View all 59.983 comments

namee_ra This photo still destroys my existence @aribaa_

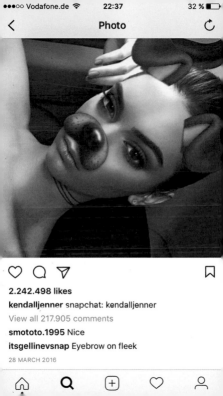

♡ 〇 ◁ ⊓

2.242.498 likes

kendalljenner snapchat: kendalljenner

View all 217.905 comments

smototo.1995 Nice

itsgellinevsnap Eyebrow on fleek

28 MARCH 2016

⌂ 🔍 ⊕ ♡ 👤

jenny.alaniz Kendall I´ve been binge watchn u n ur awesome sisters n I l9ve u all, I´m so proud of u, hey plz just be nIce to ur big sisters, I had only one sister she was older but she passed away 20 years ago, although she was mean to me in her last days I know she loved me, so plz always tell your sisters u love them

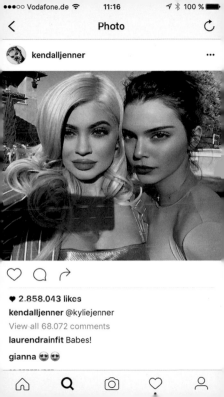

kendalljenner

♥ 2.858.043 likes
kendalljenner @kyliejenner
View all 68.072 comments
laurendrainfit Babes!
gianna 😎 😎 😎

elizaveta_kotik_mimi I know, you must happy with your friends ✸ ✸ ✸

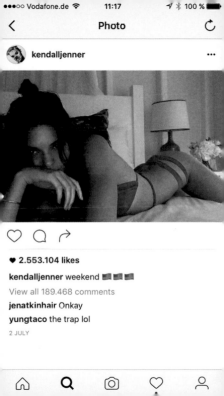

###
kyliejenner

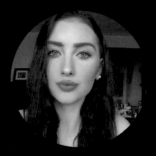

oliviajckson I wanna get fillers to have lips like this :) @mikinnakilleen

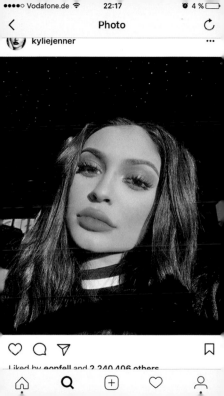

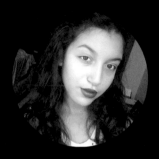

Iowns Even if i comment u will not notice me ^^ btw you slay queen

kyliejenner ...

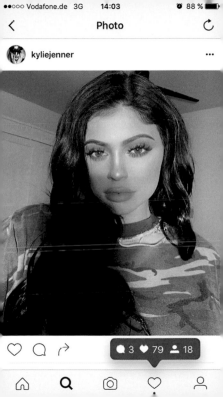

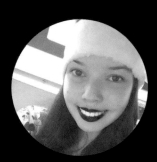

amandsrafaela You have always been my
favorite Jenner 🖤🥀. I love you babe and I really
admire you. People just should stop juding you
saying: "oh she´s so fake", because They need
to understand that everyone has a right to do
what ever they want if the y don´t feel good
about themselves. I give all my support to you,
Kylie. Love you gorgous!!! 😍 🖤 🥀 ☺️

###

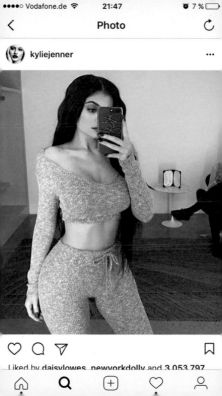

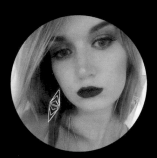

lizatheriault @emily_x0 She is beautiful too
don´t downgrade because of surgery. U would-
n´t have tha opinion if u have friends and
family with surgery. Rude...

lizatheriault People need to get over judging
others with surgery I´m saving up for a nose
job and yes I´m going to feel pretty gorgeous
afterwards and no cares given !

###

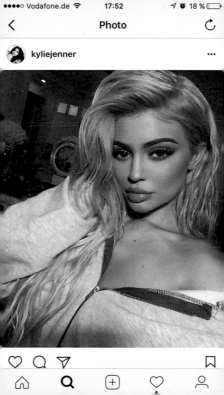

kyliejenner ···

marylinjohnson0819 You may not have implants but you definitely have injected fat in your butt and have had a augmentation in your breast. It is no way you went from what you were at 17 to what you are now just from screwing Tiger. Just own it. You lied about your lips until you had to tell the truth. People are not stupid Kylie and they are not against you because of what you have done but if you keep on denying and lying they will be, it´s not a good luck. Everybody hates a thief and a liar

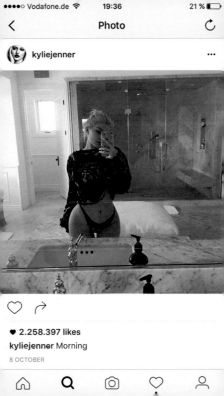

kyliejenner ···

♡ ↱

♥ **2.258.397 likes**

kyliejenner Morning

8 OCTOBER

xxariana26xx kylie u are really lucky to have money and people that support u unlike me im always crying and being depressed but i see u and i try to get that to lift me up i just think oh maybe one day ill have her perfect life

###

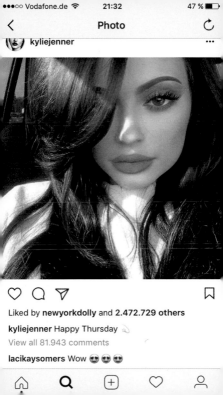

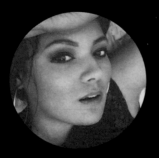

ashree_hall @leeannfaith I really really think she did something with her eyelids. I need to find out what! Like when I cry my eyelids get thicker and i get SOOOO many complements on how pretty I look the morning after I cry because my lids are puffy and nobody know why I look diffenrent.

###

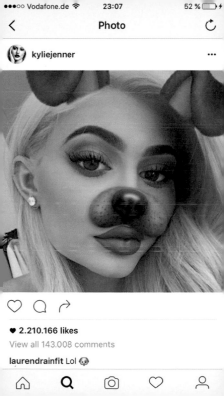

kyliejenner ...

♥ 2.210.166 likes
View all 143.008 comments
laurendrainfit Lol 🐶

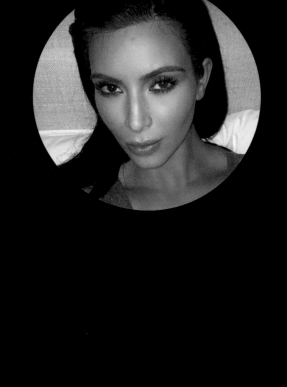

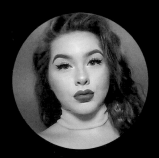

_ashlynxx 😍 😍 BODY GOALS!! 🌸

#

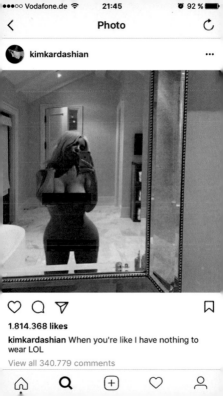

kimkardashian •••

1.814.368 likes

kimkardashian When you're like I have nothing to wear LOL

View all 340.779 comments

chary.cherry.cherrie Do u have to have big lips to look beautiful like that? Cux i have small lips and im too to do the kylie jenner lip challenge with the bottle cux i heard some people got carried away and der lips blew up. So i was just wondering

#

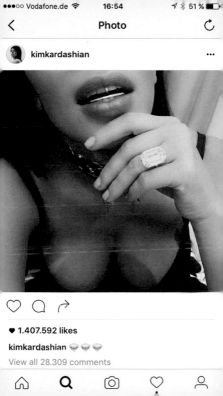

kimkardashian

♡ ◯ ↗

♥ **1.407.592 likes**

kimkardashian 💎 💎 💎

View all 28.309 comments

sweetlifeapparel Selfie goals @mzwong27

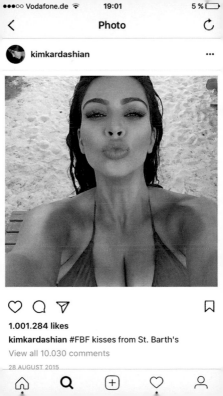

kimkardashian

1.001.284 likes

kimkardashian #FBF kisses from St. Barth's

View all 10.030 comments

28 AUGUST 2015

chiccafrancescasaveria Thanks for women With forms like yours, you learn to love our bodythanks

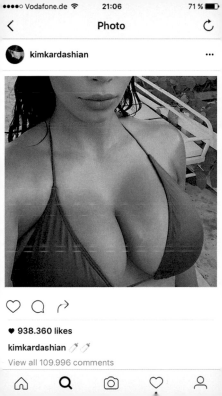

kimkardashian ···

♡ ○ ↪

♥ 938.360 likes

kimkardashian 🔪💉

View all 109.996 comments

🏠 🔍 📷 ♡ 👤

sophietashina @eunoianisa I love myself but
this picture makes me want to kms 😍😍😍

#

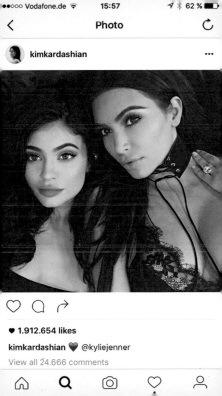

kimkardashian ···

♡ ◯ ➚

♥ 1.912.654 likes

kimkardashian 🖤 @kyliejenner

View all 24.666 comments

⌂ 🔍 ◎ ♡ 👤

msalygolightly Check out my recreated look of you pleaaaaaaaasssseeeeeee KIM 🙈 🤍

#

kimkardashian ...

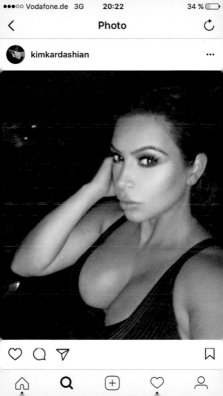

Diese Publikation erscheint anlässlich der Absolventenausstellung der
HFBK Hochschule für bildende Künste Hamburg / This book is published
in conjunction with the graduation exhibition of HFBK Hochschule für
bildende Künste Hamburg

HFBK Hochschule für bildende Künste Hamburg
14.07–16.07. 2017

Gestaltung / Design:
Chris Drange

Projektmanagement / Project management:
Sonja Altmeppen, Hatje Cantz

Lektorat (Vorwort) / Copyediting (preface):
Alexander Mees

Übersetzung / Translation:
Isolda Mac Liam

Verlagsherstellung / Production:
Anja Wolsfeld, Catharina Czipf

Reproduktionen / Reproductions:
Chris Drange

Druck / Printing:
Offsetdruckerei Karl Grammlich GmbH, Pliezhausen

Papier / Paper:
Gardamatt Art 170 g/m²

Buchbinderei / Binding:
Lachenmaier Buch kreativ OHG, Reutlingen

Chris Drange möchte sich bedanken bei / Chris Drange would like to thank:
Nadine Barth, Patrick Becker, Wigger Bierma, Adam Broomberg,
Oliver Chanarin, Hilda Engstrand, Fine Art Service, Franziska Goes,
Dr. Andrea Klier, Martin Köttering, Emil Kowalczyk, Christian Pietschmann,
Anselm Reyle, Cristina Steingräber.

Erschienen im / Published by
Hatje Cantz Verlag GmbH
Mommsenstraße 27
10629 Berlin
Deutschland / Germany
Tel. +49 30 3464678-00
Fax +49 30 3464678-29
www.hatjecantz.com
Ein Unternehmen der Ganske Verlagsgruppe
A Ganske Publishing Group Company

Hatje Cantz books are available internationally at selected bookstores.
For more information about our distribution partners, please visit our
website at www.hatjecantz.com.

ISBN 978-3-7757-4362-4

Printed in Germany

Purple Earth Foundation

Realisiert mit:

MATERIALVERLAG–HFBK